APERTURE MASTERS OF PHOTOGRAPHY

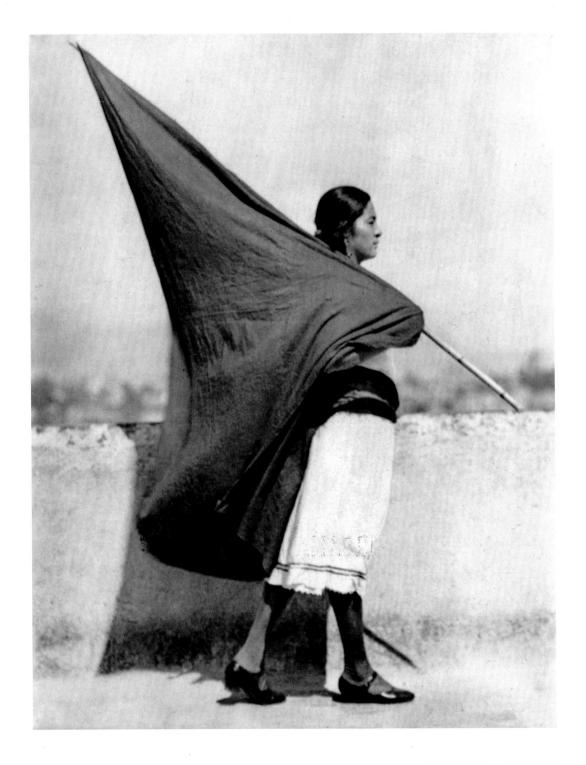

TINA MODOTTI

With an Essay by Margaret Hooks

MASTERS OF PHOTOGRAPHY

APERTURE

H-04 ₽ 2.50

Frontispiece: Woman with flag, 1928

Photographs courtesy: front cover and frontispiece Throckmorton Fine Art, NY; p. 11 Margaret Hooks; pp. 13–17 Throckmorton Fine Art, NY; p. 19 George Eastman House, Rochester, NY; p. 21 Throckmorton Fine Art, NY; p. 23 Philadelphia Museum of Art: Gift of Mr. and Mrs. Carl Zigrosser; p. 25 The J. Paul Getty Museum, Los Angeles, CA; p. 27 National Gallery of Canada, Ottawa; p. 29 The Minneapolis Institute of Arts, MN; pp. 31–37 Throckmorton Fine Art, NY; p. 39 Margaret Hooks; p. 41 Center for Creative Photography, The University of Arizona, Tucson; p. 43 Margaret Hooks; p. 45 The Baltimore Museum of Art, MD: Purchase with exchange funds from the Edward Joseph Gallagher III Memorial Collection, and Partial Gift of George H. Dalsheimer; p. 47 Throckmorton Fine Art, NY; p. 49 The Art Institute of Chicago; p. 51 Fototeca del INAH, Mexico: Donation Carlos Vidali; p. 53 Throckmorton Fine Art, NY; p. 55 collection National Gallery of Australia, Canberra; pp. 57–59 Throckmorton Fine Art, NY; p. 61 Fototeca del INAH, Mexico: Donation Carlos Vidali; p. 63 Throckmorton Fine Art, NY; p. 65 Margaret Hooks; p. 67 Throckmorton Fine Art, NY; p. 69 Cincinnati Art Museum, OH, Museum Purchase: Gift of the Estate of Clara J. Schawe, Mrs. Ralph Robertson, and Lane Seminary, by exchange; p. 71 Throckmorton Fine Art, NY and Collection of Edmundo Kronfle, Jr.; p. 73 Throckmorton Fine Art, NY; p. 75 Amon Carter Museum, Fort Worth, TX; p. 77 The Museum of Modern Art, NY, courtesy of Isabel Carbajal Bolandi; p. 79 Throckmorton Fine Art, NY; p. 81 Fototeca del INAH, Mexico: Donation Carlos Vidali; p. 83 Throckmorton Fine Art, NY; p. 85 Fototeca del INAH, Mexico: Donation Carlos Vidali; p. 87 The Bertram D. Wolfe Collection, Hoover Institution Archives, Stanford, CA; pp. 89–91 Throckmorton Fine Art, NY; p. 92 New Orleans Museum of Art, LA; back cover Throckmorton Fine Art, NY.

Printed in Hong Kong.
Library of Congress Catalog Number: 98-86910
ISBN: 0-89381-823-2

This 1999 edition is a coproduction of Könemann Verlags GmbH and Aperture Foundation, Inc.

Aperture Foundation publishes a periodical, books, and portfolios of fine photography to communicate with serious photographers and creative people everywhere. A complete catalog is available upon request. Address: 20 East 23rd Street, New York, New York 10010. Phone: (212) 598-4205. Fax: (212) 598-4015. Toll-free: (800) 929-2323. Visit Aperture's website: http://www.aperture.org

The Aperture Masters of Photography series is distributed in the following territories through Könemann Verlags GmbH, Bonner Str. 126, D-50968 Köln, Germany. Phone: (0221) 3799-0. Fax: (0221) 3799-88: *Continental Europe, Israel, Australia, and the Pacific Rim except Japan*. The series is distributed in the following territories through Aperture: *Canada*: General Publishing, 30 Lesmill Road, Don Mills, Ontario, M3B 2T6. Fax: (416) 445-5991. *United Kingdom*: Robert Hale, Ltd., Clerkenwell House, 45–47 Clerkenwell Green, London EC1R OHT. Fax: 44-171-490-4958. *All other territories*: Aperture, 20 East 23rd Street, New York, New York 10010. Phone: (212) 505-5555. Fax: (212) 979-7759.

For international magazine subscription orders for the periodical *Aperture*, contact Aperture International Subscription Service, P.O. Box 14, Harold Hill, Romford, RM3 8EQ, England. Fax: 1-708-372-046. One year: £30.00. Price subject to change.

To subscribe to the periodical *Aperture* in the U.S.A. write Aperture, P.O. Box 3000, Denville, New Jersey 07834. Phone: (800) 783-4903. One year: $40.00. Two years: $66.00.

K2 K4 K6 K8 K7 K5 K3 K1

TINA MODOTTI

Margaret Hooks

Now recognized as a seminal pre-war photographer, Tina Modotti (1896–1942) lived her life on the crest of the major movements in art and politics of the first half of the twentieth century. A thoroughly modern woman who smoked a pipe and was among the first to wear denim overalls, Modotti flouted convention in her personal and professional relationships, and in her photographs. As an engaged artist, she agonized over the conflict between life and art—between the purity of inspired creation and the demands of a world fractured by social injustice.

Modotti was familiar with social inequities from an early age. Born in the northern Italian city of Udine, one of her earliest memories was of her father, Guiseppe Modotti, lifting her high on his shoulders at a May Day rally to hear his fellow workers' songs and speeches. A few years later, in search of a better life for himself and his family, he emigrated to America. His departure plunged the family into a poverty that Tina would never forget. At barely fourteen years old, she became the family's only wage earner, working long, difficult hours in a local silk factory.

Over time, as his economic situation improved, Guiseppe sent for his wife and children to join him in San Francisco. Tina arrived in 1913 and quickly found a job as a seamstress in the prestigious I. Magnin department store. She was not long in the sewing room, however, before her romantic good looks attracted the attention of her employers, who hired her to model the store's latest fashions.

In 1915, San Francisco hosted the Pan-Pacific Exposition and there Tina first came into contact with modern art and photography movements. In its exotic ambience she also met and fell in love with her future husband, the soulful, bohemian painter and poet, Roubaix de l'Abrie Richey, known as Robo. Just one year later, she had given up modeling for acting in the local Italian theater, appearing mainly in some rather bad operettas. Nevertheless, Modotti's considerable acting talent and adoring public made her the toast of the neighborhood and probably led to her "discovery" by a talent scout from the growing silent film industry in Hollywood.

Tina Modotti arrived in Los Angeles in late 1918, and was cast in leading roles in the feature-length melodramas *The Tiger's Coat* and *I Can Explain*. However, she soon realized that Hollywood directors had difficulty imagining an Italian woman as anything

other than a vamp. But there was more to Los Angeles than Hollywood for Modotti and Robo. They had become part of an avant-garde circle which included artists and anarchists, World War I draft evaders and dancers fascinated with art and free love, Eastern mysticism and the Mexican Revolution.

Through this new group of friends, Modotti met the well-known American photographer Edward Weston, then married with four young sons. In a letter to his close friend and fellow photographer Johan Hagemeyer, Weston wrote, "I not only have done some of the best things yet but also have had an exquisite affair . . . the pictures I believe to be particularly good are of one Tina de Richey—a lovely Italian girl." Modotti viewed these striking portraits as a joint effort between artist and model, and this collaboration initiated one of the most exciting partnerships in photographic history.

Modotti and Weston's ongoing affair led Robo to remove himself temporarily to Mexico, where he died suddenly and tragically from smallpox just two days after Modotti had arrived to visit him. She stayed on in Mexico City to oversee an exhibit of his work and that of Edward Weston and other American photographers, but her stay was cut short by her father's sudden illness and subsequent death just a few weeks later.

This double loss and the deepening relationship with Weston brought about a new self-awareness in Modotti. She was no longer satisfied with the stereotypical parts she was being offered by Hollywood, nor with her role as model for the cameras of Edward Weston, Johan Hagemeyer, Jane Reece, and other members of Weston's circle. She began to run Weston's studio on occasion, go on photographic outings with him and Hagemeyer, and assist them in the darkroom. These experiences together with her childhood visits to the studio of her uncle, Pietro Modotti, a prominent Udine photographer, probably led to Modotti's later decision to establish her own photographic studio, a venture her father had also embarked on, albeit unsuccessfully, when he first arrived in San Francisco.

In July 1923, Modotti returned to Mexico, this time with Weston, his son Chandler, and an agreement that in exchange for helping him run his studio Weston would teach her photography. Post-revolutionary Mexico was in the throes of a social and cultural renaissance, and their Mexico City home became a renowned gathering place for artists, writers, and radicals such as Diego Rivera, Anita Brenner, and Jean Charlot. Their boisterous Saturday night parties were an opportunity for cross-dressing, plotting revolution, and exchanging ideas on art.

Under Weston's instruction Modotti developed rapidly as a photographer, and although his influence on her work is clear, she quickly took a direction of her own. Unafraid of experimentation, or of challenging Weston's purist maxims, she cropped and enlarged many of her images and explored the potential of multiple exposures and photomontage. From Weston, Modotti learned the principles of modernist photography and made several images in this vein, such as *Roses*, *Telephone wires*, and *Doors*.

But the longer she was in Mexico the more she felt the need to respond through her photography to the upheavals over land reform and social injustice roiling the nation. This impulse led to some of her best work, a melding of a modernist aesthetic with Mexican revolutionary culture—she was able to take form and give it content. Examples of this are *Workers' parade*, a shot of a column of peasant farmers marching on May Day 1926; *Mexican peasant boy*; and the carefully composed "icons" of the revolution—the sombrero, the bandolier, the guitar, and the ear of corn—in the series "Study for a Mexican Song."

At the center of Mexico's cultural revolution were the larger-than-life muralists who competed for wall space for their magnificent, gargantuan paintings. Through her friendship with these painters, especially Diego Rivera, for whom she posed on several occasions, Modotti became the most sought-after photographer of their work. As a result of this close working relationship, she became influenced by the muralists' communist ideas and ideals. But Modotti was not a political theorist and was seemingly naive about the ideological debates taking place among Communists at the time. Her political involvement at this point was primarily to participate in campaigns to free political prisoners and to help promote international liberation movements. Not surprisingly, Modotti was experiencing difficulty in fusing the many facets of her life. "Art cannot exist without life," she wrote at the time, "but . . . in my case life is always struggling to predominate and art naturally suffers."

Her growing social conscience was driving her and Weston apart and she had put their relationship on a platonic footing. Moreover, he missed his children and wanted to return to the United States, while she wanted to stay in Mexico, where she not only felt at home in the midst of the social upheaval but felt she had a role in it. Their separation in November 1926 marked an end to their Mexican idyll. It saddened both, and though they never saw each other again, they communicated frequently, sharing their work and innermost thoughts, until 1931, when Modotti's new life in Stalinist Russia led her to sever all communication with him.

Following Weston's departure, Modotti entered her most productive period as a photographer, running her own professional studio and creating some of her most commanding images: *Mella's typewriter*, *Hands resting on tool*, and *Worker carrying beam*. Her work can be divided loosely into four categories: photographs of Mexico and Mexican folk art for leading art periodicals and her documentation of the work of renowned Mexican artists for publication in books; photojournalism for *El Machete*, which includes the majority of her most poignant studies of the disparities in Mexican society, together with her documentation of Communist Party rallies, reunions, and other events; her studio "bread and butter" work—professional portraits of Mexico's rich, famous, and outrageous; and the images she made for pure pleasure—the sensual forms of slender lilies, the sinuous shapes of women embracing their children, and the strong

abstract lines of wood scaffolding and telegraph wire.

Modotti's home had become a hive of activity for Latin American exiles as her support for their liberation struggles grew. It was also a gathering place for Mexican artists such as Rufino Tamayo, the photographer Manuel Álvarez Bravo, and the young Frida Kahlo. In 1928, she began living with the dynamic young Cuban revolutionary-in-exile, Julio Antonio Mella. They had been together only a few months when he was gunned down at her side on a dark Mexico City street by his political opponents.

Despite the murder's obvious political overtones, the Mexican government used the trial to attack the Communists, trying to show they were immoral by implicating Modotti in a "crime of passion." The ensuing investigation became a virtual inquisition on her sexuality. Her home was ransacked by the police and Weston's nude studies of her were seized as proof of her immorality, causing irreparable damage to her reputation and career. On the one hand, there was the embarrassment of the Communist Party rank and file, modest farmers and workers unfamiliar with art photography who did not understand the context of these works, and on the other, the horror of leading members of Mexican society, whose portraits Modotti earned her living making, reading in their daily newspapers that their nice Italian photographer was in fact a "depraved communist."

Eventually Modotti was acquitted, but Mella's assassination and the ordeal of the trial brought home to her the virulent reaction that could occur in the struggle to bring about social change. Although she emerged emotionally battered and mentally exhausted from the experience, it strengthened her and irrevocably changed her perception of the world. She no longer felt there was any middle ground; life for her was now a matter of absolutes. If previously she had been a photographer with a cause, she was now a revolutionary with a mission. A new zeal drove her to follow in Mella's footsteps.

And as a photographer, what better way to do so than to continue the work they had done for the Mexican Communist Party (PCM) newspaper *El Machete*? In 1928, when Mella was the paper's chief writer, Modotti had published an innovative series in the paper under the title, "The Contrasts of the Regime." Images of poverty and degradation such as *Misery* and *Poverty and elegance* were juxtaposed with images of wealth to reveal the discrepancies of post-revolutionary Mexico. Soon after Mella's death, on May Day 1929, Modotti took her photojournalism a step further with an assignment from *El Machete* to cover a march protesting the crackdown on the PCM. The eighteen images made that day with her Graflex camera depict the event's relaxed, jovial beginning, follow it through Mexico City's streets to the United States embassy, capture the subsequent arrival of the police to disperse the crowd, and record the violence of the march's end.

These images show that Modotti was at ease with reportage, moving quickly to record dramatic events. This new, more aggressive role indicates a change in

attitude; the slow, careful composition and aesthetic of an image were no longer of such importance to her.

In an interview with Carleton Beals for a 1929 article on her photography in *Creative Art*, Modotti described her new outlook as a desire to produce nothing other than "the perfect snapshot." By snapshot she did not mean amateur, but rather, impromptu photographs. "The moving quality of life rather than still studies absorb her," Beals wrote.

Later that year, following a visit to the Isthmus of Tehuantepec, famed for its strong, strikingly handsome women, Modotti wrote to Weston that the photographs she had taken there were "snapshots." With some wonderful exceptions, many of the photographs made on that trip do have that quality, and appear to be largely an attempt to document the customs, environs, and apparel of the women of this region.

Back in Mexico City, scandal continued to follow Modotti, as did the secret police, who kept vigil outside her home. It further erupted when her first solo exhibition opened in December 1929. The "First Revolutionary Photography Exhibit" reflected Modotti's preoccupations with producing "revolutionary" art, indicative of which was her choice of the firebrand muralist David Alfaro Siqueiros to inaugurate the show. He was arrested a few days later for conspiring against the government and in the ensuing publicity, Modotti's lifestyle was once again dragged into the Mexican press. Ironically, in the midst of this political activity, Modotti's photography was gaining more international recognition; articles on her work were appearing in magazines such as *Creative Art*, *transition*, and *BIFUR*, and Agfa was using her endorsement to sell their film.

In early 1930, an attempt on the Mexican president's life and a subsequent crackdown on PCM members led to Modotti's arrest and deportation to Europe. On the boat to Europe, she deepened her friendship with Soviet agent Vittorio Vidali, a fellow Italian she had met in Mexico in 1927. He tried to persuade her to accompany him to Moscow, but she wanted to stay in Berlin. While there, she came into contact with the Bauhaus school of photographers and designers, with whose work she was already familiar through publications she had seen in Mexico. She met local photographer Lotte Jacobi, who organized an exhibit of Modotti's work, which was well received by local critics. But Modotti found it impossible to adjust to her new surroundings. She complained bitterly in her letters about the light, her camera, and the Germans. The few photographs she did make there reflect her mood and are a somewhat cruel parody of German life.

Within six months Modotti had given in to Vidali's persuasion and joined him in Moscow. Once there, she realized that her photography did not comply with socialist realism, Stalin's concept of "revolutionary" art. She decided to give up the camera completely, a decision she had been considering for some time, to devote herself to combating fascism through work for International Red Aid. Her choice of political activism over art is understandable in the context of the absolutist idealism of her time.

Using various identities, she entered fascist-controlled countries to assist the families of political prisoners. Detection would almost certainly have meant torture, and even death. In 1936, Modotti and Vidali were in Spain for the outbreak of the Civil War. He became renowned in the defense of Madrid as "Comandante Carlos," and Modotti, under the name Maria, played a key role in directing international aid to the Republican cause. Following Franco's victory in 1939, she returned reluctantly to Mexico. Living incognito as Dr. Carmen Sanchez, she avoided her friends from the 1920s, associating mainly with fellow political refugees from fascism.

In 1940, Modotti worked with a photographic expedition for a book documenting President Lazaro Cardenas's revolution in health, education, and land reform in Mexico, but she refused to take any photographs. Towards the end of 1941, she began to contact some of her old friends, such as the muralist José Clemente Orozco, and there is an indication that she was trying to acquire a camera to start photographing again. But fate intervened, and on the night of January 6, 1942, on her way home from a dinner party given by her friend, Bauhaus architect Hannes Meyer, Modotti died of an alleged heart attack in the back seat of a Mexico City taxicab.

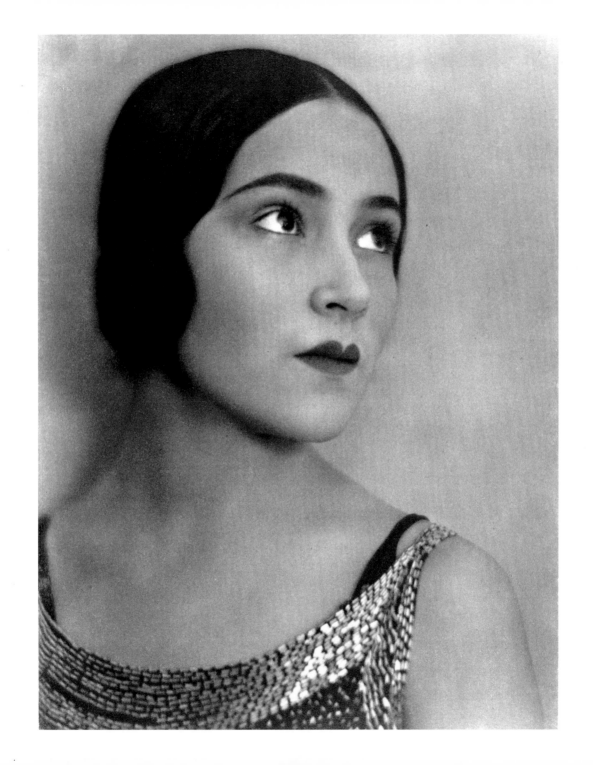

Jean Charlot, 1924

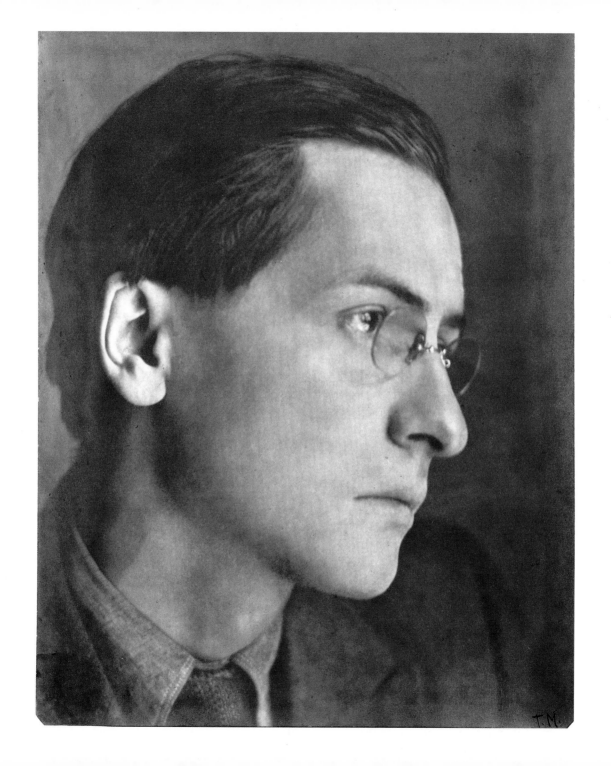

14 Woman of Tehuantepec carrying *jecapixtle*, 1929

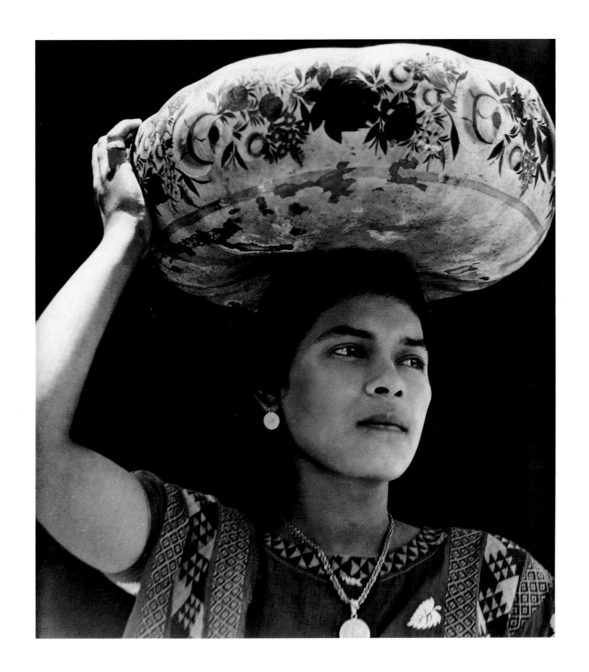

16 Calla lily, ca. 1925

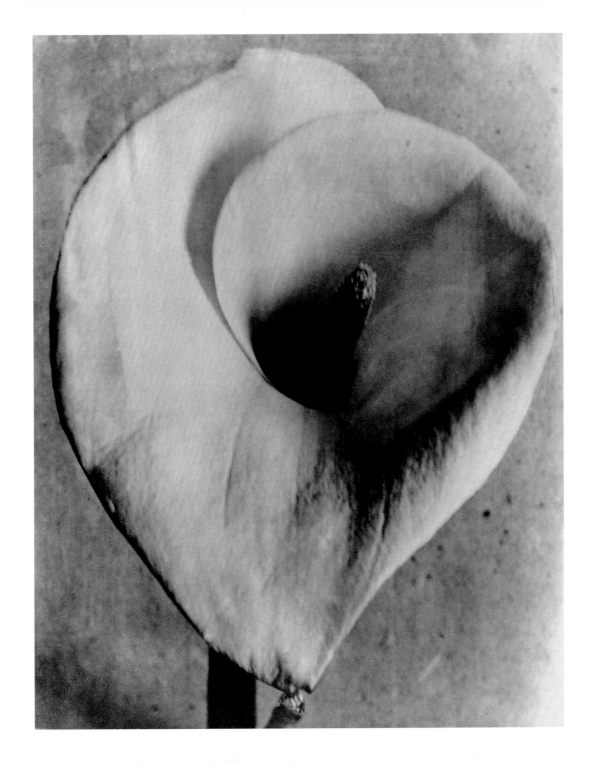

18 Woman with *olla*, 1926

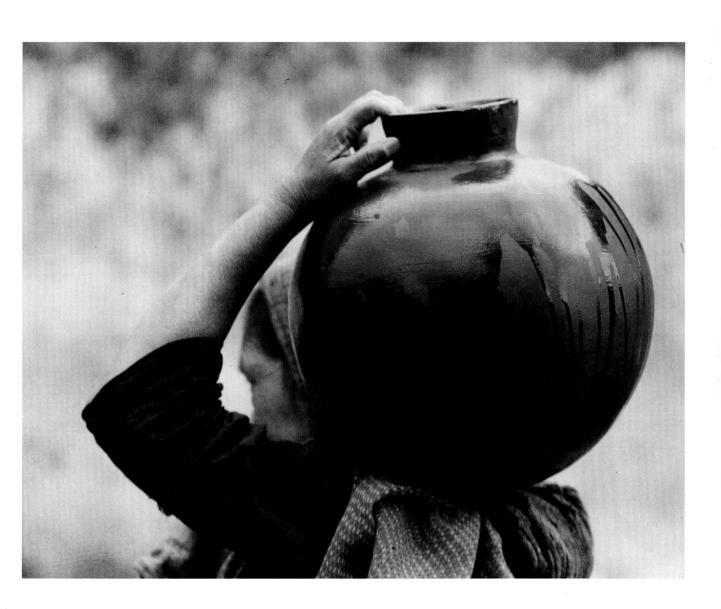

20 Roses, 1925

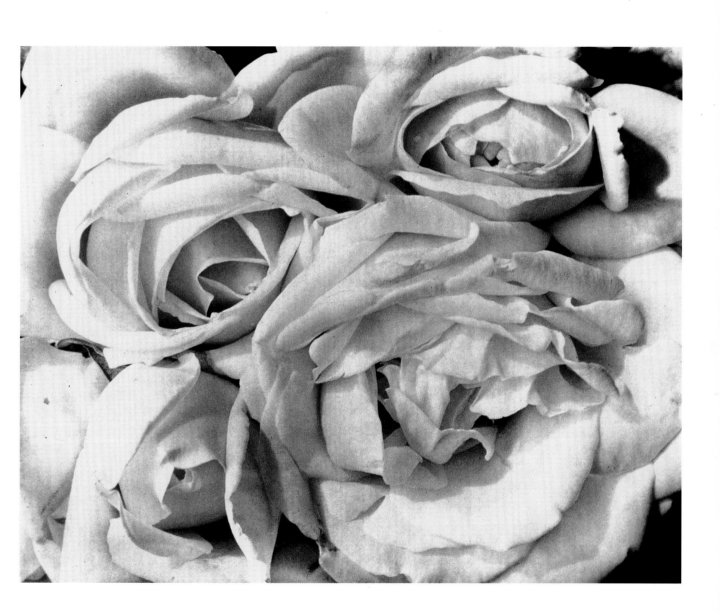

Mother and child, Tehuantepec, 1929

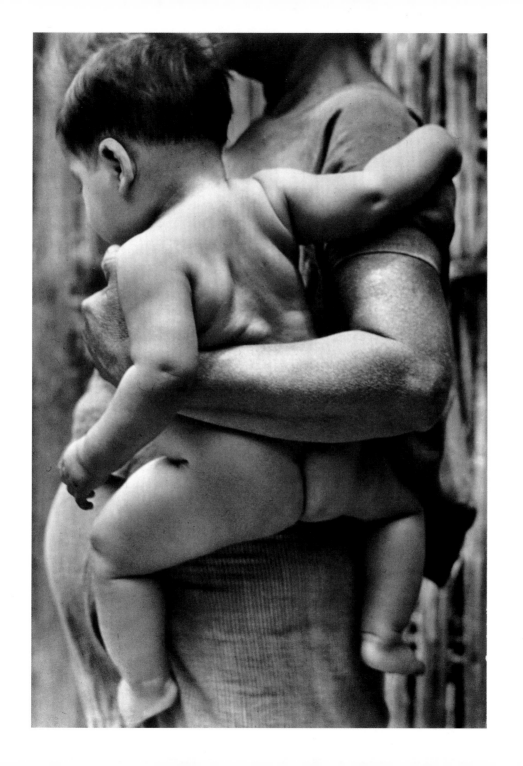

24 Hands resting on tool, 1927

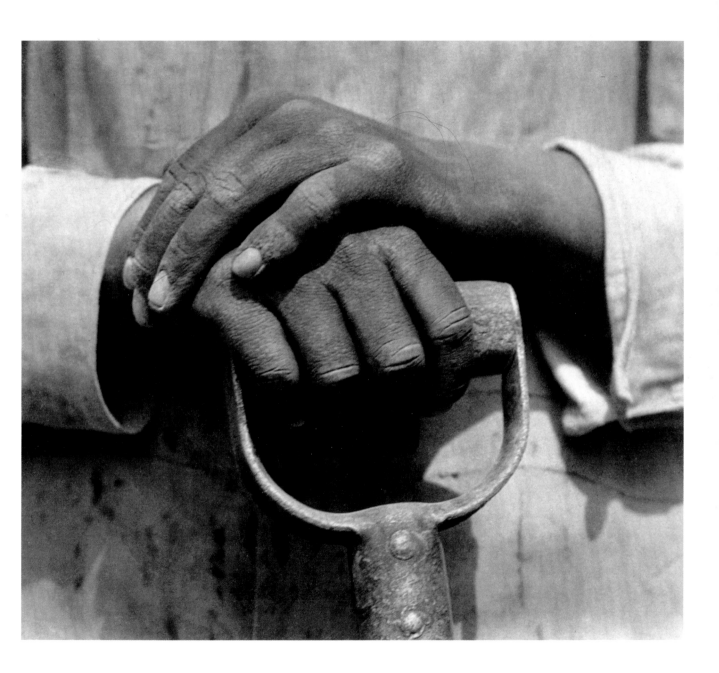

26 *Flor de manita,* ca. 1925

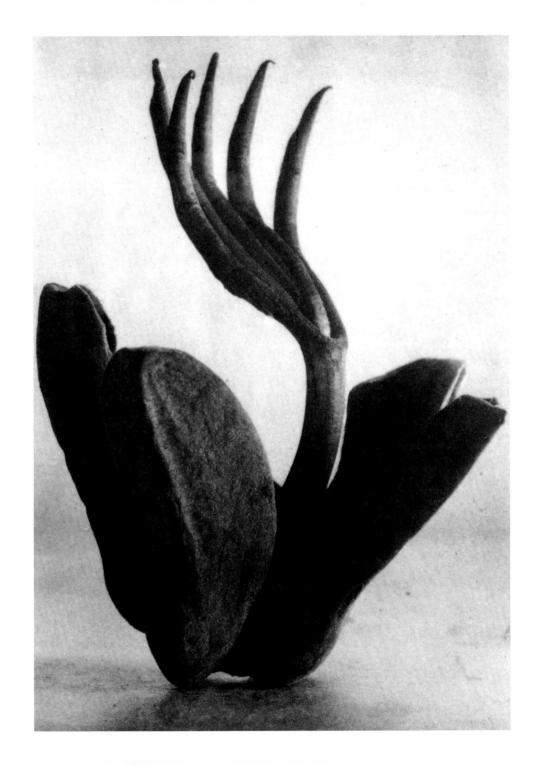

28 Hands of the puppeteer, 1929

30 Louis Bunin with dancing puppet, 1929

Police puppets, 1929

Women of Tehuantepec, 1929

Pacheco painting a mural, 1927

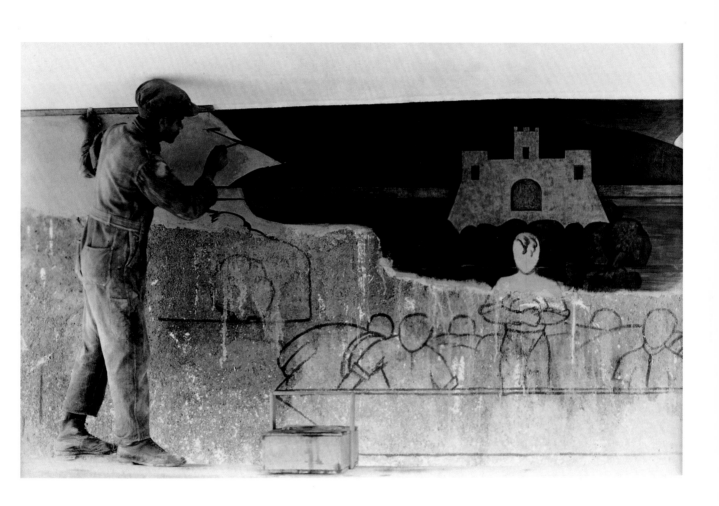

José Clemente Orozco at work, 1927

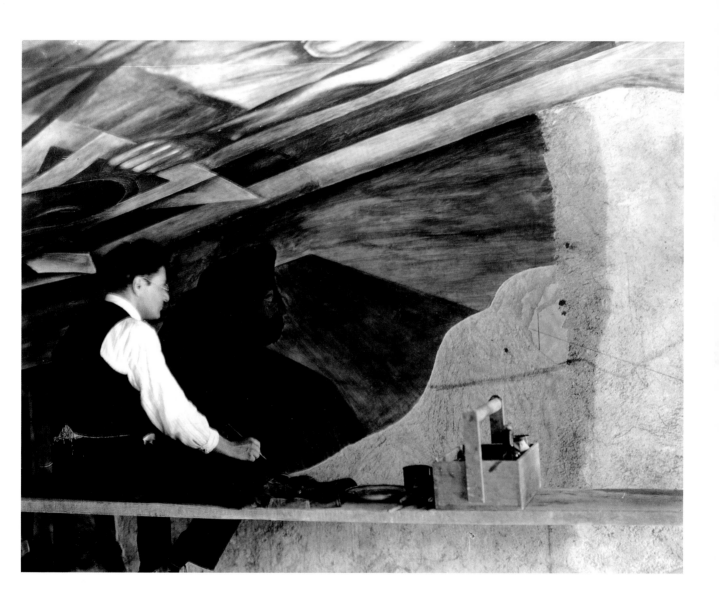

40 Circus tent, 1924

Scaffolding, ca. 1925

Telephone wires, 1925

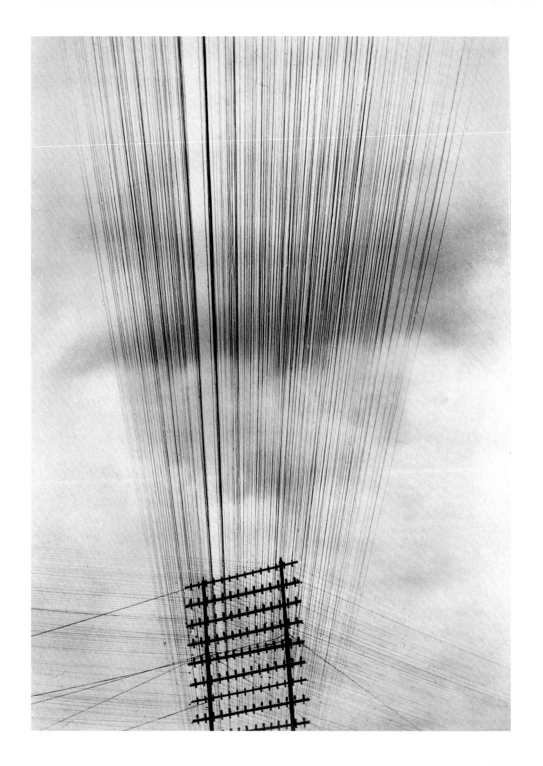

46 Tank no. 1, 1927

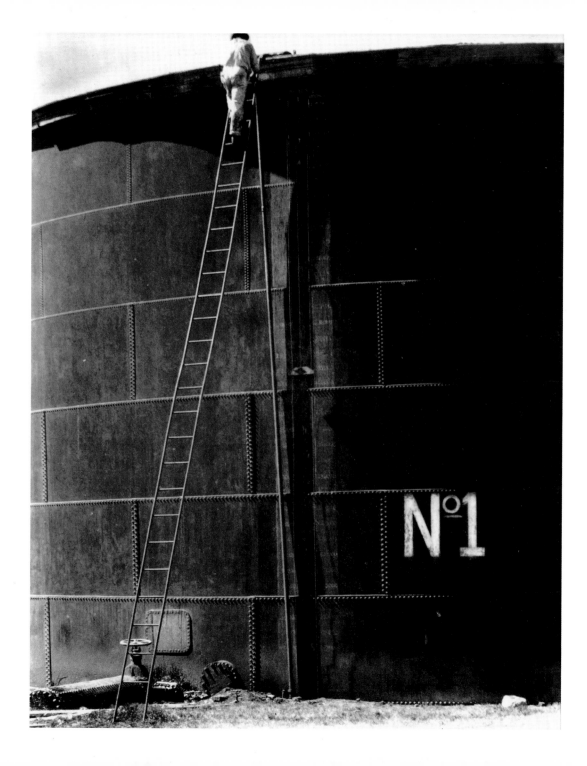

48 Interior of church, Tepotzotlan, 1924

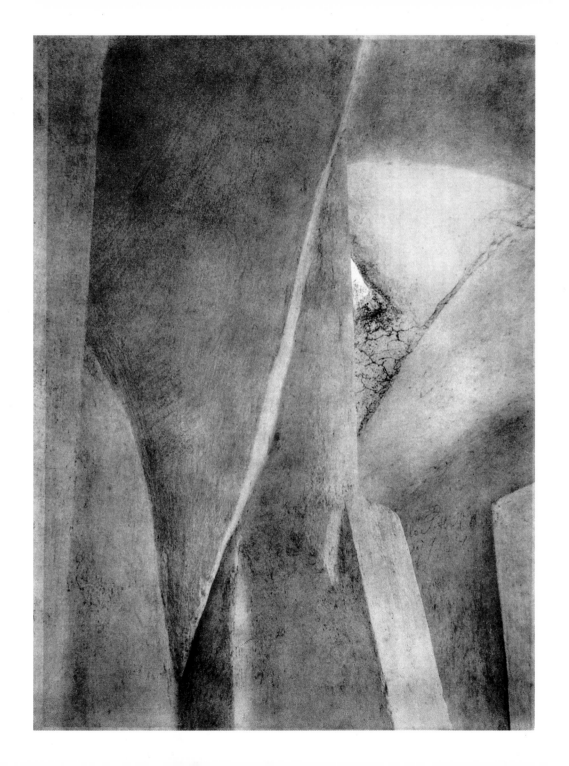

50 Stadium, Mexico City, ca. 1927

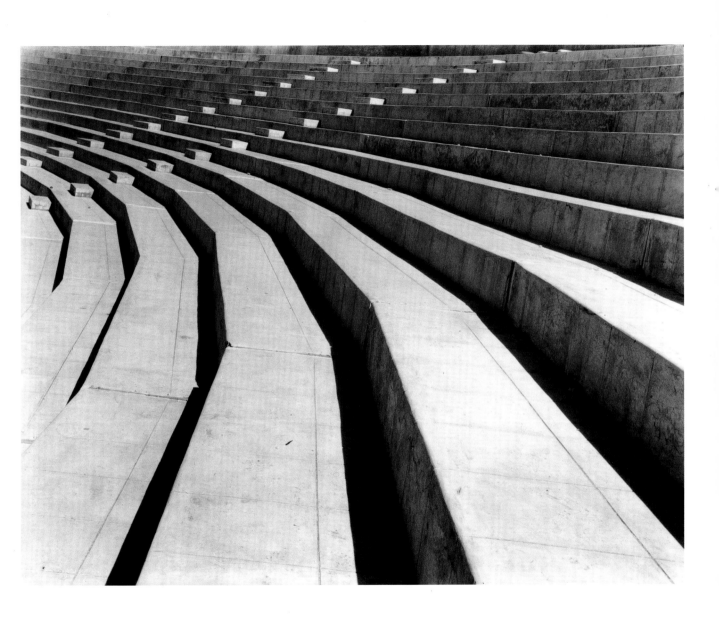

52 Julio Antonio Mella's typewriter, 1928

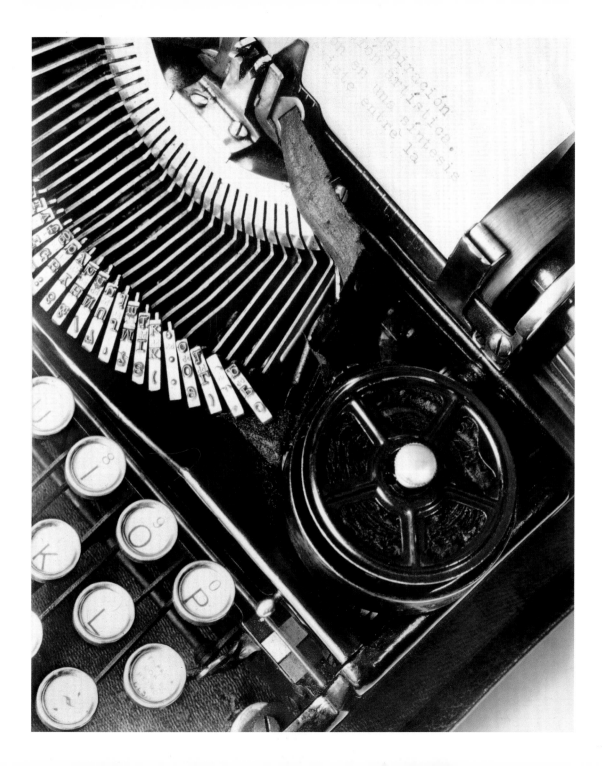

54 Mexican sombrero with hammer and sickle, 1927

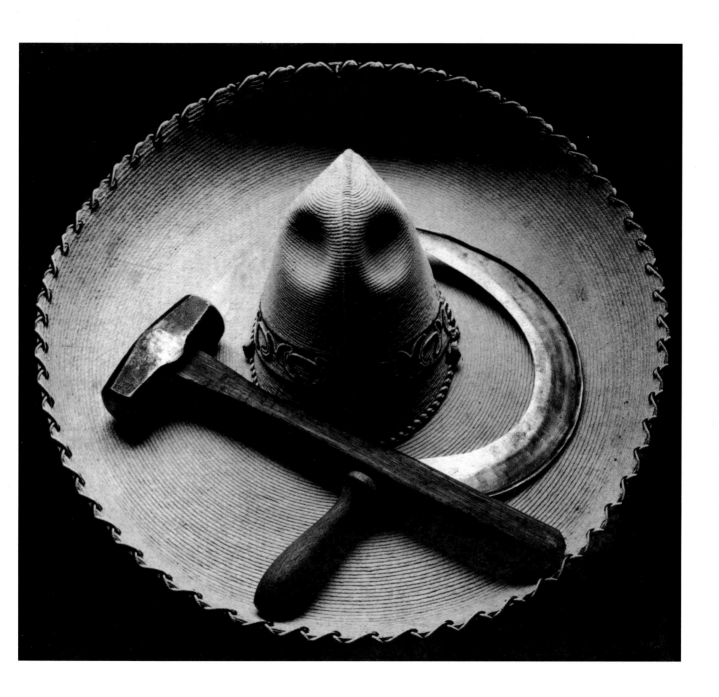

56 Bandolier, corn, guitar, 1927

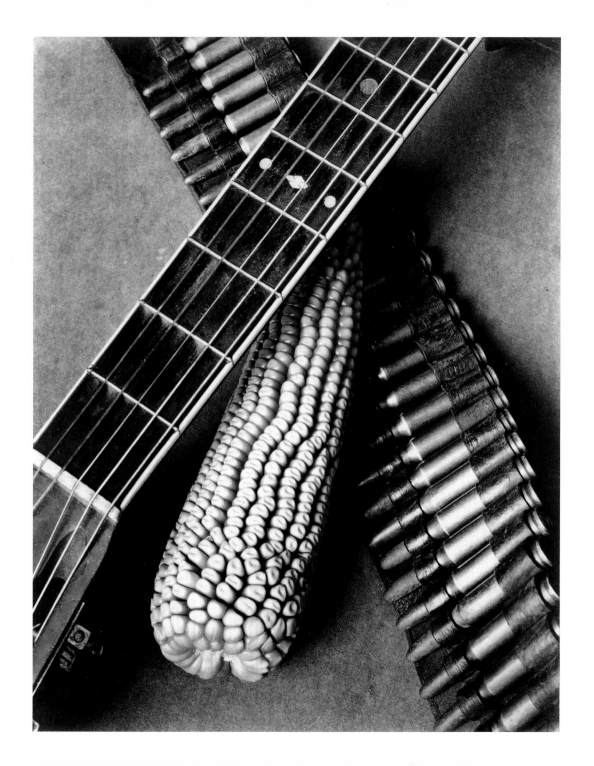

58 Wine glasses, 1925

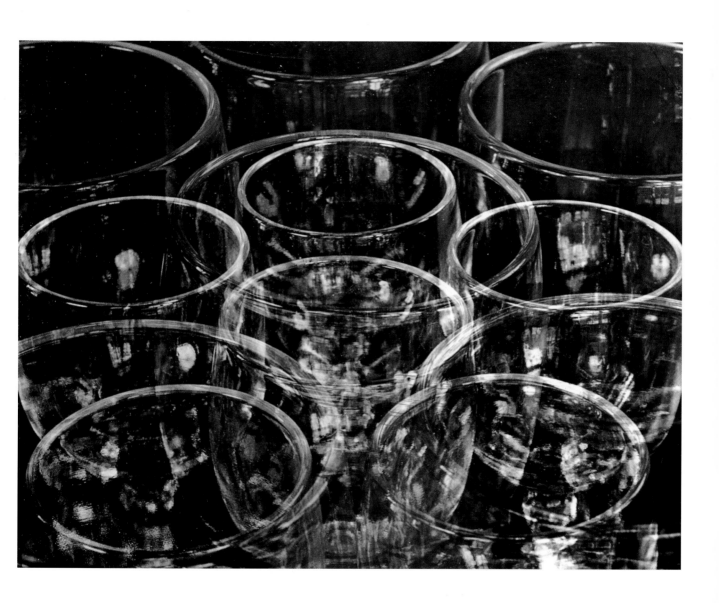

Mexican peasants reading *El Machete*, 1928

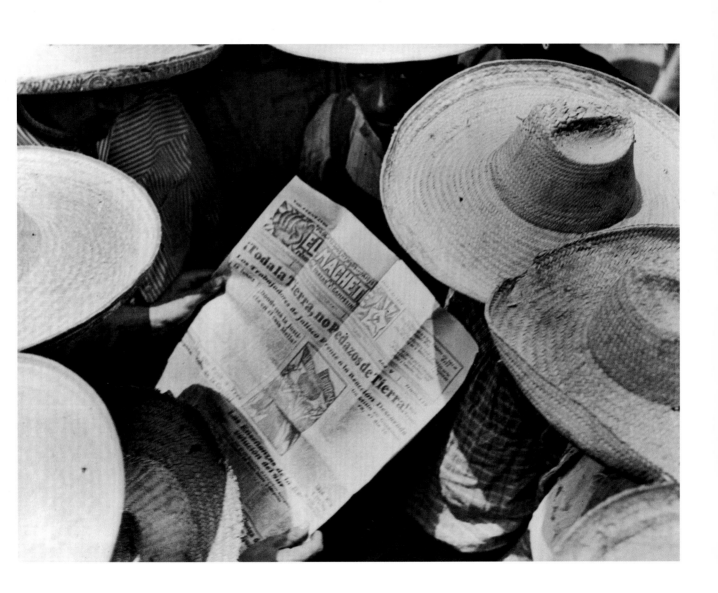

62 Workers' parade, 1926

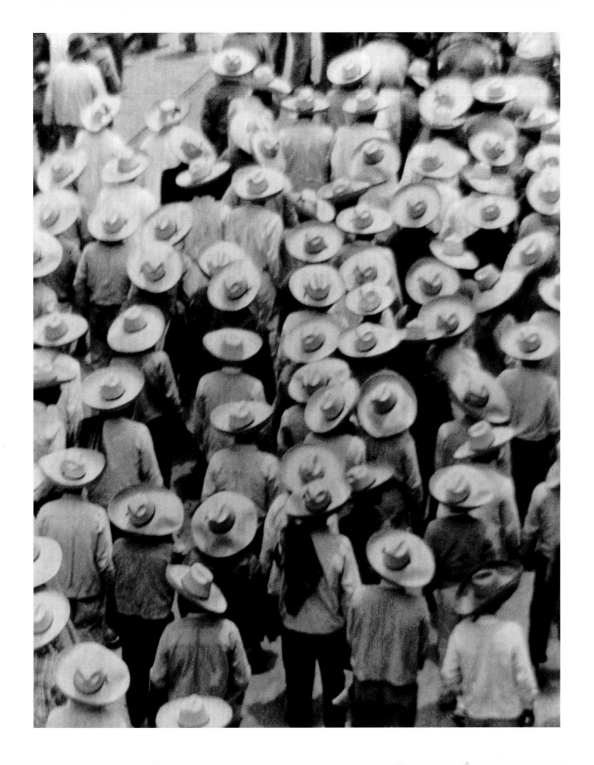

64 Antonieta Rivas Mercado, 1929

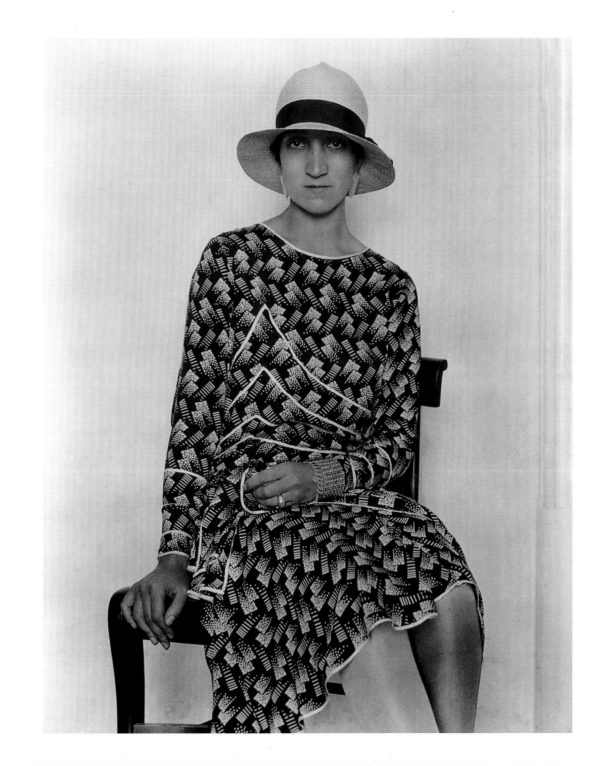

Three ways to wear a serape, ca. 1927

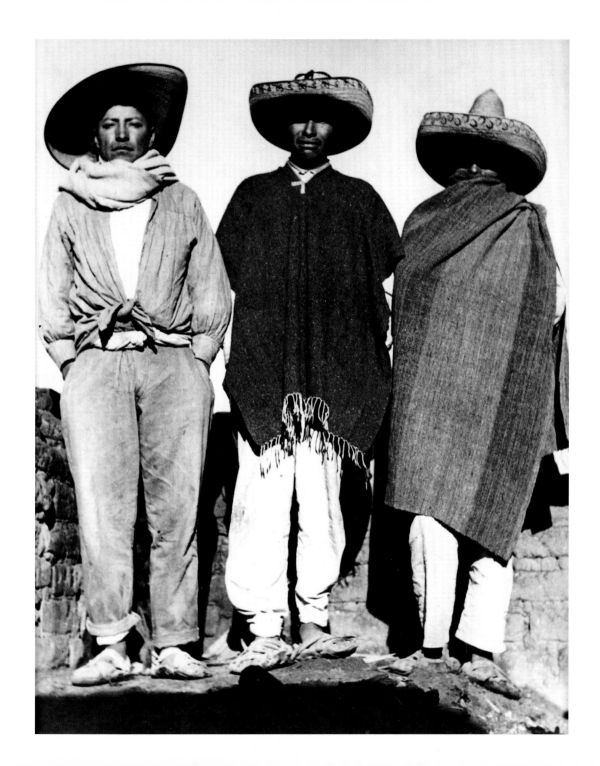

68 German youth group, 1930

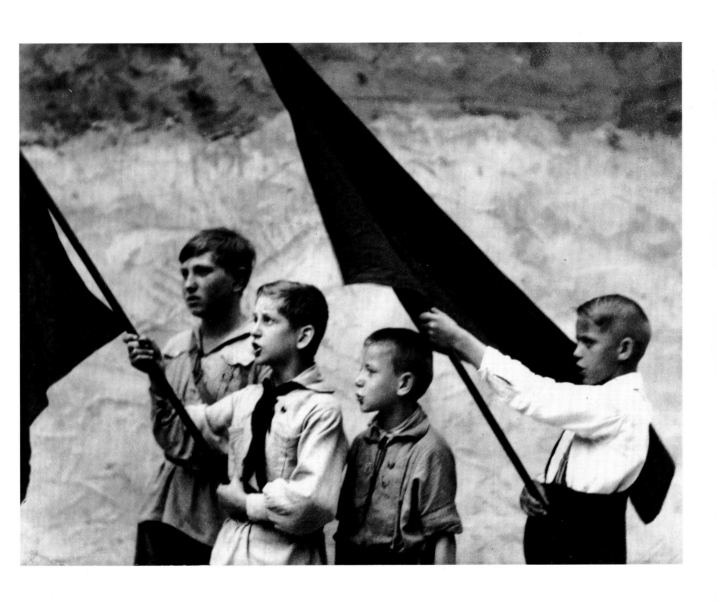

Loading bananas, Veracruz, 1928

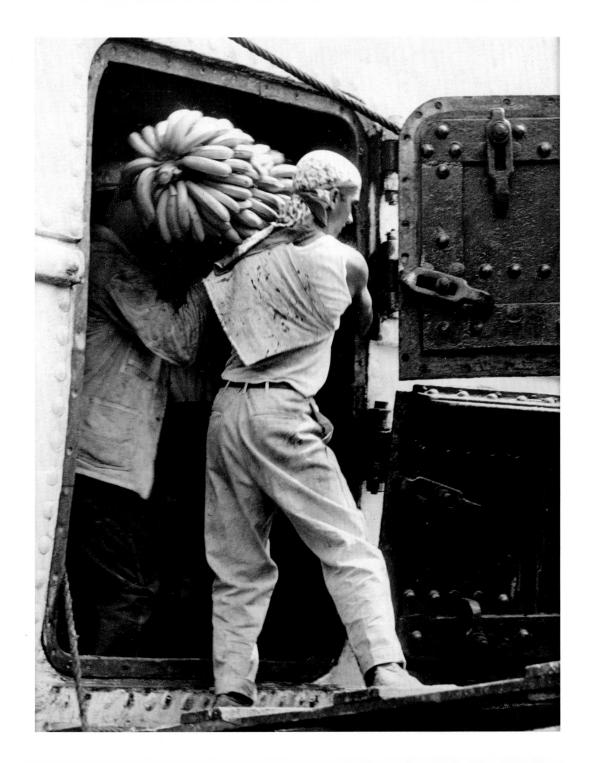

72 Luz Jimenez breast-feeding her baby, ca. 1925

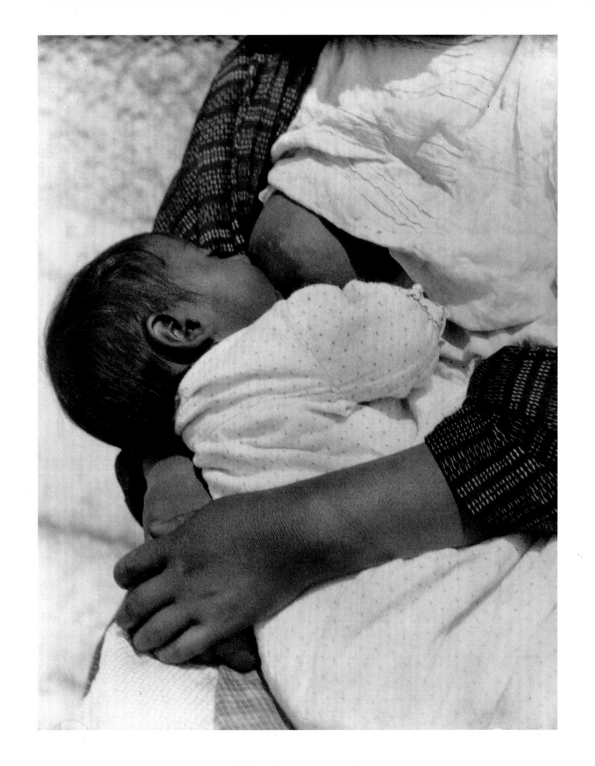

74 Workers, ca. 1926–29

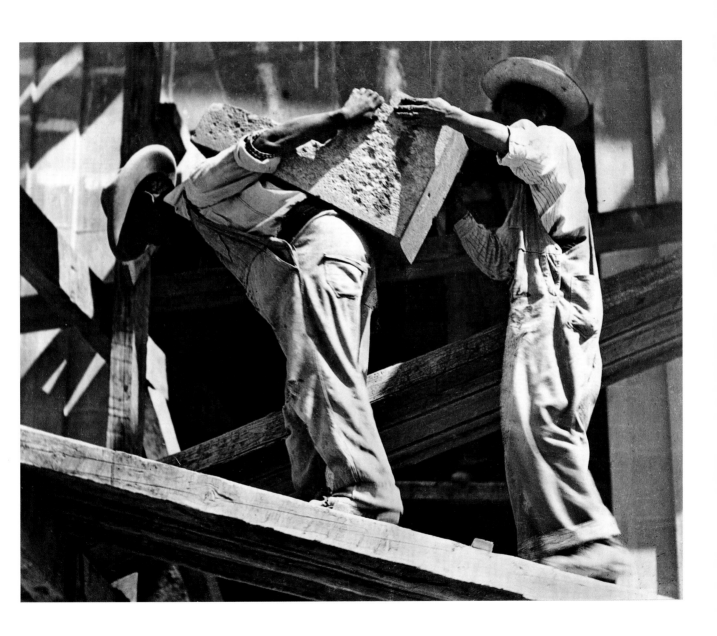

Poverty and elegance, 1928

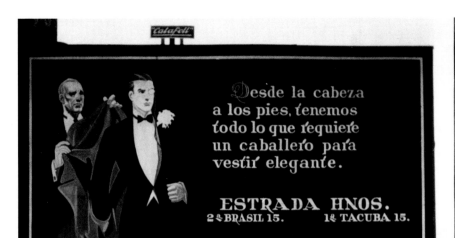

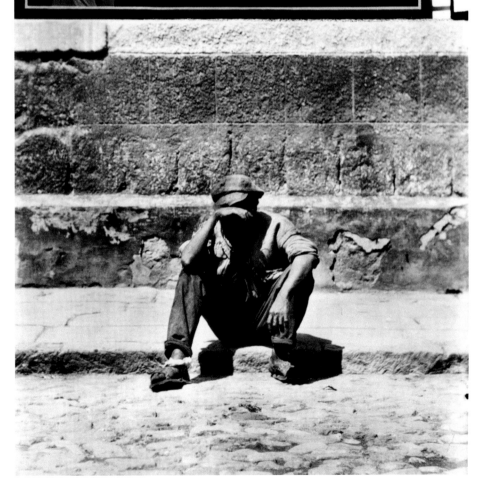

Rafael on the *azotea*, ca. 1924

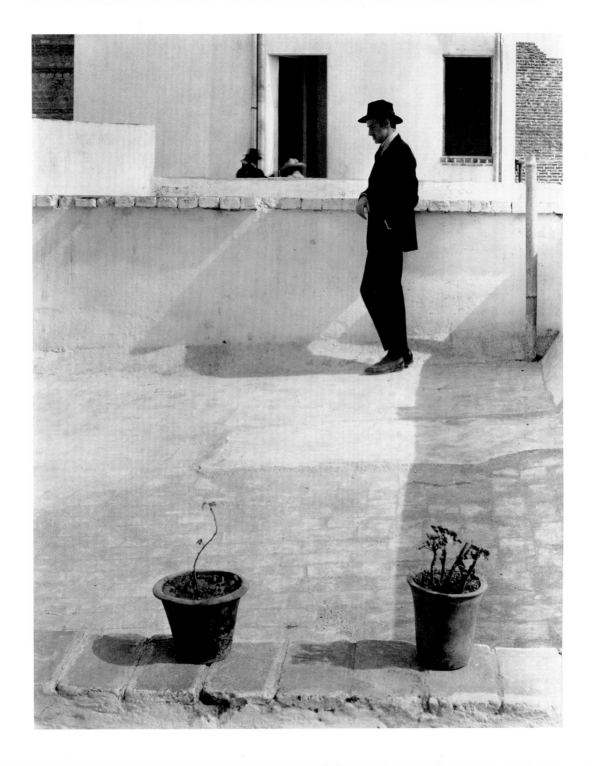

A peasant family in Veracruz, 1927

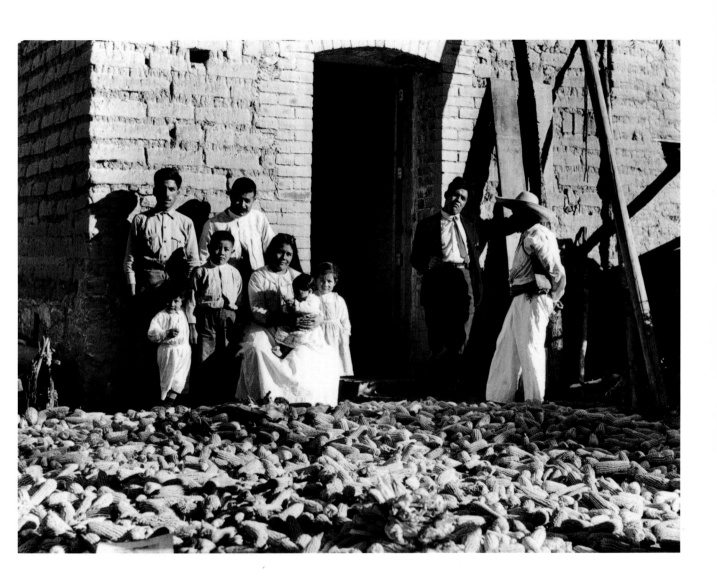

Fiesta in Juchitán, 1929

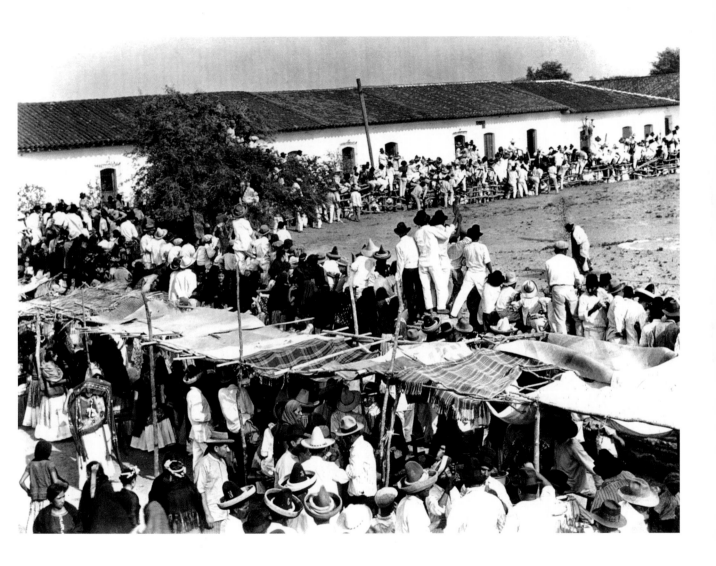

84 Vittorio Vidali, 1930

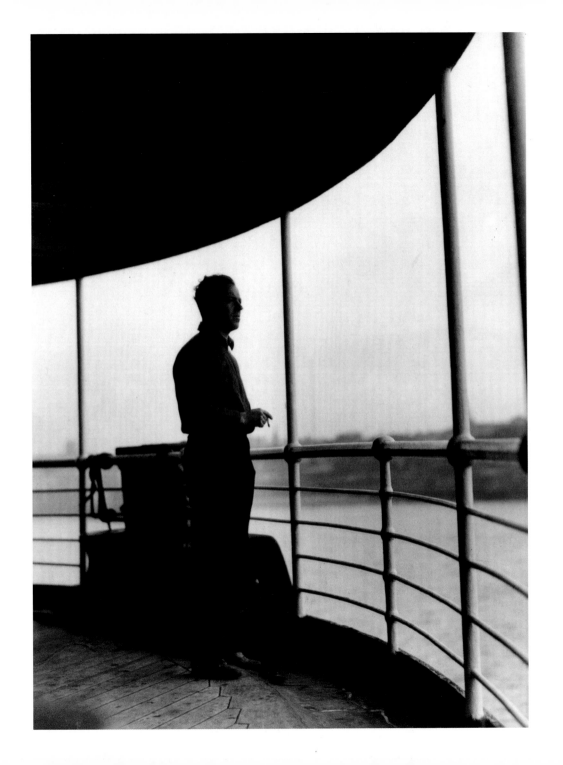

86 Diego Rivera and Frida Kahlo at the May Day march, 1929

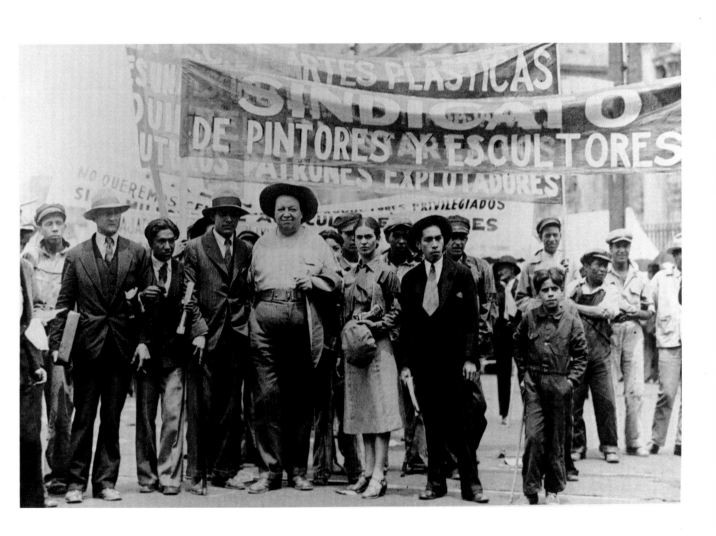

Detail of *In the Arsenal*, Diego Rivera mural at the Ministry of Education, Mexico City, 1928

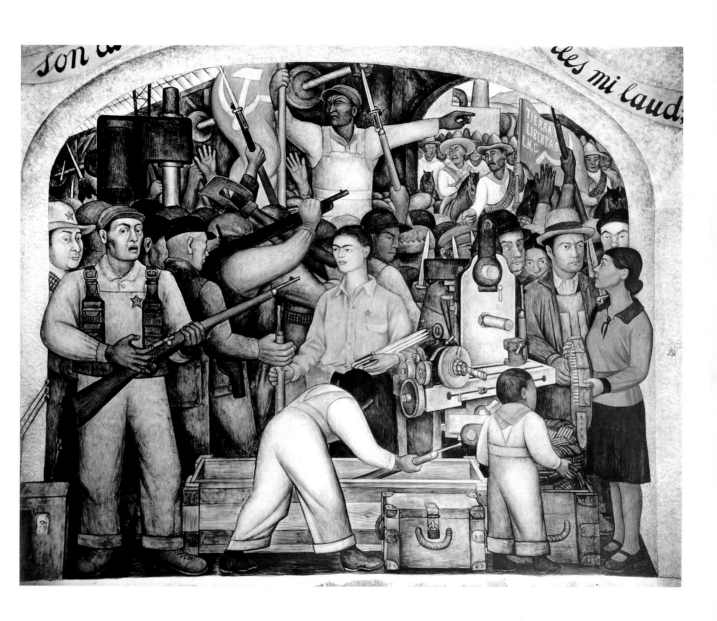

Julio Antonio Mella, 1928

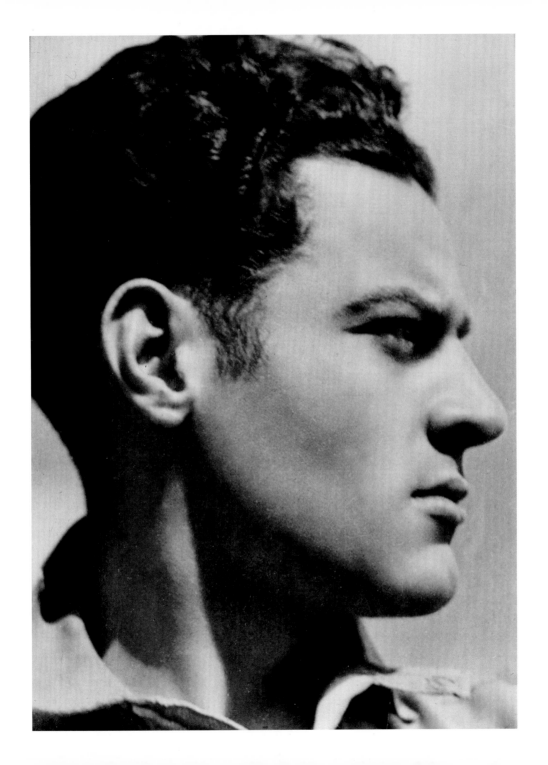

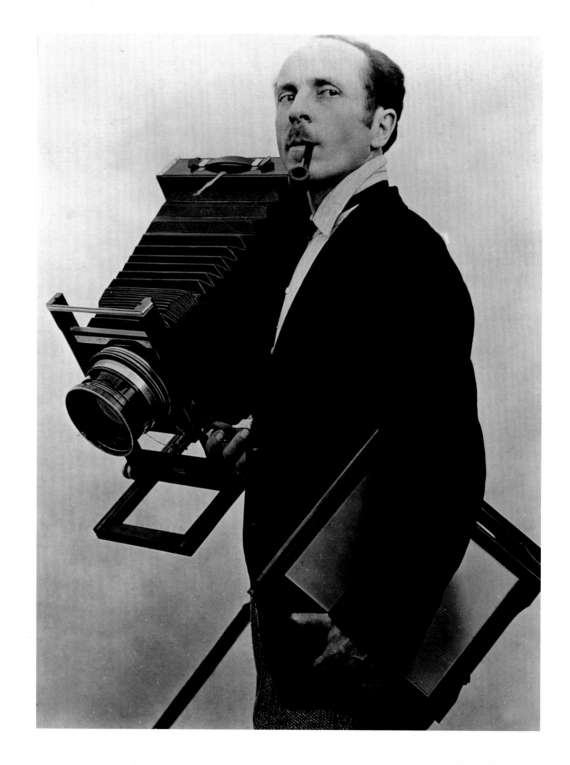

BRIEF CHRONOLOGY

1896. Born August 17, Udine, Italy.

1898. Moves with family to Austria.

1905. Returns to Udine.

1908. Begins working in silk factory.

1913. Emigrates to the United States, joining father and sister in San Francisco.

1915. Attends Pan-Pacific Exposition and meets future husband, poet and painter Roubaix de l'Abrie Richey (Robo).

1917–18. Performs in local Italian theater. Moves to Los Angeles.

1920. Acts in silent films. Plays leading role in *The Tiger's Coat.*

1921. Begins posing for Edward Weston.

1922. Trip to Mexico where Robo dies suddenly. Arranges exhibit of work by Robo, Weston, and other California artists.

1923. Moves to Mexico with Weston, manages his studio, and begins taking photographs with Korona camera.

1924. First exhibit of work, wins runner-up prize. Begins collaboration with *Mexican Folkways* magazine.

1925. Becomes official photographer of Diego Rivera's murals, temporarily takes over Weston's studio work, and shows with him in joint exhibit.

1926. Starts using Graflex camera. Wins prize in collective exhibit. Travels throughout Mexico with Edward and Brett Weston taking photographs to illustrate Anita Brenner's *Idols Behind Altars.* Becomes involved in proposed film on history of Mexican revolution using her photographs of murals. Weston leaves Mexico.

1927. Joins Mexican Communist Party. Takes photographs of Party events and to illustrate *El Canto de Los Hombres* by *estridenista* poet German List Arzubide. Publishes work in *New Masses* and *Creative Art.*

1928. Lives with Cuban rebel, Julio Antonio Mella. Embarks on photojournalism project for Party newspaper, *El Machete.* Shares first prize in collective show. Continues publishing in *AIZ, New Masses,* and *Creative Art.*

1929. Mella gunned down by her side. Ensuing murder trial attacks Modotti's morality. Visits Tehuantepec and photographs local women. Agfa uses work to endorse their film. Publishes in *Vanity Fair.* First solo exhibit.

1930. Framed for attack on Mexican president, arrested and expelled from Mexico. Travels to Berlin. Experiences difficulty in continuing her photography. Moves to Moscow. Joins Soviet Communist Party and becomes immersed in political work.

1931. Gives up photography. Works full time for Comintern.

1932–33. Based in Paris, carries out undercover missions throughout Europe to aid political prisoners and their families.

1935–39. Participates in Spanish Civil War as "Maria," working for International Red Aid.

1939. Returns to Mexico incognito.

1942. Dies in Mexico City taxicab in the early hours of January 6.

SELECTED BIBLIOGRAPHY

Books and Catalogs:

Barckhausen Canale, Cristianne. *Verdad y Leyenda de Tina Modotti*. Havana: Casa de las Americas, 1989.

Constantine, Mildred. *A Fragile Life*. New York: Rizzoli, 1983.

Hooks, Margaret. *Tina Modotti: Photographer & Revolutionary*. London: Pandora/HarperCollins, 1993.

Modotti, Tina, ed. *The Book of Robo*. Los Angeles: n.p., 1923.

Modotti, Tina. *The Letters from Tina Modotti to Edward Weston. The Archive*. Tucson: Center for Creative Photography, University of Arizona. 1986. No. 22.

Newhall, Nancy, ed. *The Daybooks of Edward Weston: I. Mexico*. Millerton, New York: Aperture, 1973.

Philadelphia Museum of Art. *Tina Modotti Photographs*. New York: Harry N. Abrams Inc., 1996.

Vidali, Vittorio. *Retrato de mujer*. Puebla: Universidad Autonoma de Puebla, 1984.

Whitechapel Art Gallery. *Frida Kahlo and Tina Modotti*. London: Whitechapel Art Gallery, 1982.

Articles:

Beals, Carleton. "Tina Modotti." *Creative Arts*, February 1929. Vol. 4, no. 2.

Hooks, Margaret. "Assignment, Mexico: Mystery of the Missing Modottis." *Afterimage*, November 1991. Vol. 19, no. 4.

Kramer, Hilton. "Tina Modotti's Brief but Remarkable Career." *New York Times*, January 23, 1977.

Modotti, Tina. "On Photography." *Mexican Folkways*, October–December 1929. Vol. 5, no. 4.

Rivera, Diego. "Edward Weston and Tina Modotti." *Mexican Folkways*, April–May 1926. Vol. 20, no. 1.

Vestal, David. "Tina's Trajectory." *Infinity*, 1966. Vol. 15, no. 2.

Publications in Which Modotti Published Her Work :
Books:

Brenner, Anita. *Idols Behind Altars*. New York: Biblo & Tannen, 1929.

Das Riveras. Berlin: n.p., 1928.

Evans, Ernestine. *The Frescos of Diego Rivera*. New York: Delphic Studios, 1932.

Reed, Alma. *José Clemente Orozco*. New York: Delphic Studios, 1932.

Smith, Susan. *Made in Mexico*. New York: Knopf, 1930.

Periodicals:

Arbeiter Illustreirte Zeitung (AIZ). Berlin, 1928–31.

BIFUR. Paris, 1928.

Contemporaneos. Mexico City, 1927–30.

Creative Art. New York and London, 1929.

CROM Magazine. Mexico City, 1927–30.

Forma. Mexico City, 1926–28.

Horizonte. Jalapa, Mexico, 1926–28.

International Literature. Moscow, 1935–36.

L'Art Vivant. Paris, 1930.

El Machete. Mexico City, 1926–29.

Mexican Life. Mexico City, 1925–31.

Mexican Folkways. Mexico City, 1924–30.

New Masses. New York, 1927–30.

Revista de revistas. Mexico City, 1930–42 and 1917–18.

transition. Paris, 1929.

El Universal Grafico. Mexico City, 1929–30.

El Universal Ilustrado. Mexico City, 1922–30.

SELECTED EXHIBITIONS

Solo Exhibitions:

1929. Biblioteca Nacional, Mexico City.

1930. Studio of Lotte Jacobi, Berlin.

1942. Galeria de Arte Mexicano, Mexico City.

1977. Museum of Modern Art, New York.

1995. Philadelphia Museum of Art, Philadelphia.

Other Exhibitions:

1924. Palacio de Mineria, Mexico City.

1925. State Museum of Guadalajara, Jalisco, Mexico.

1926. Galeria de Arte Moderno, Mexico City.

1927. *Tenth International Salon of Photography*. Los Angeles Museum, California.

1929. Berkeley Art Museum, California.

1930. Harvard Society for Contemporary Art, Cambridge, Massachusetts.

1932. Brooklyn Museum, New York.

1982. Whitechapel Gallery, London.